Lacy Sunshine's
Flower Pot Hatchlings
Coloring Book

Illustrated by
Heather Valentin

©Heather Valentin. Lacy Sunshine. Alll Rights Reserved. No redistribution without artist consent

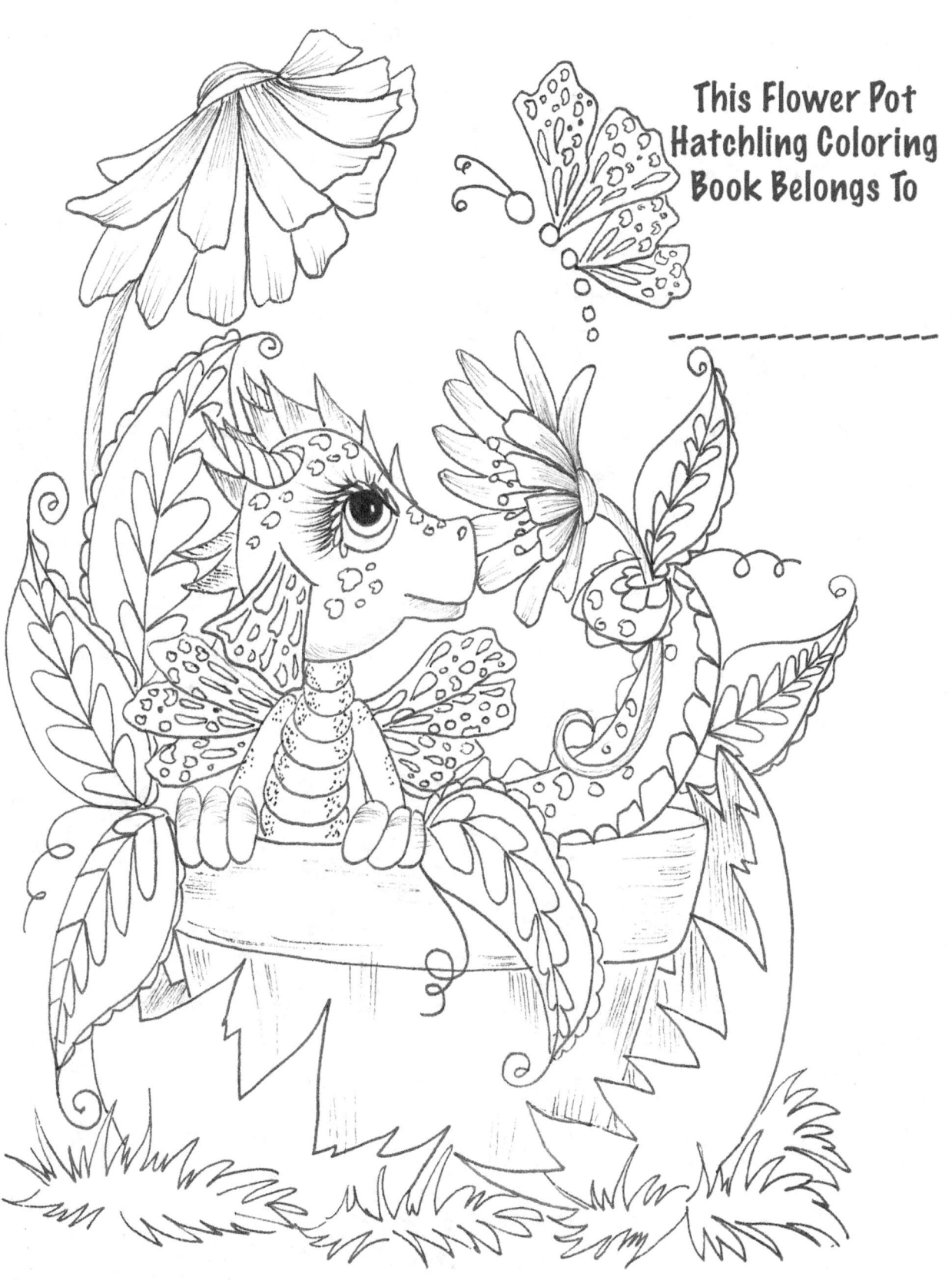

This Flower Pot Hatchling Coloring Book Belongs To
_____

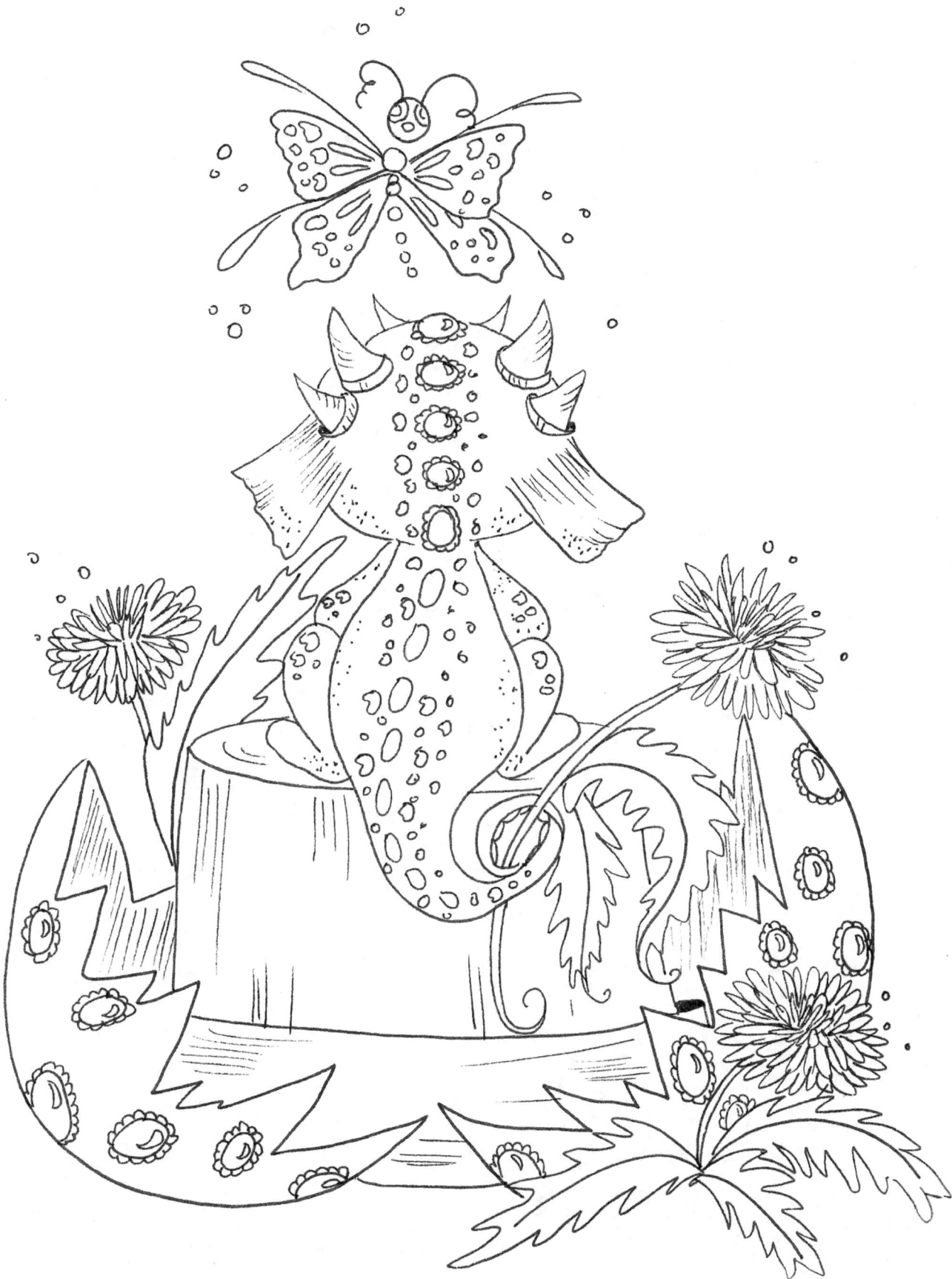

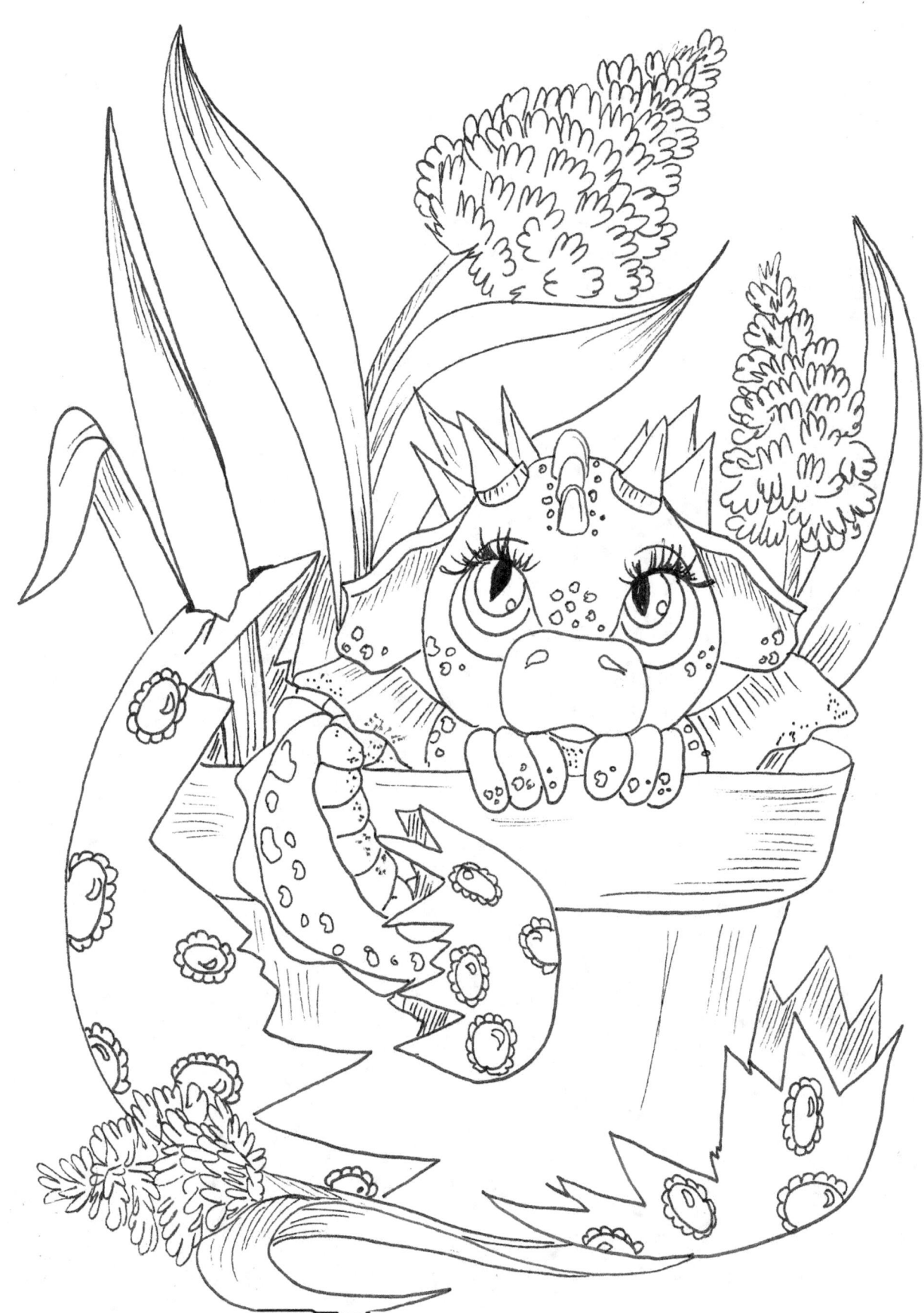

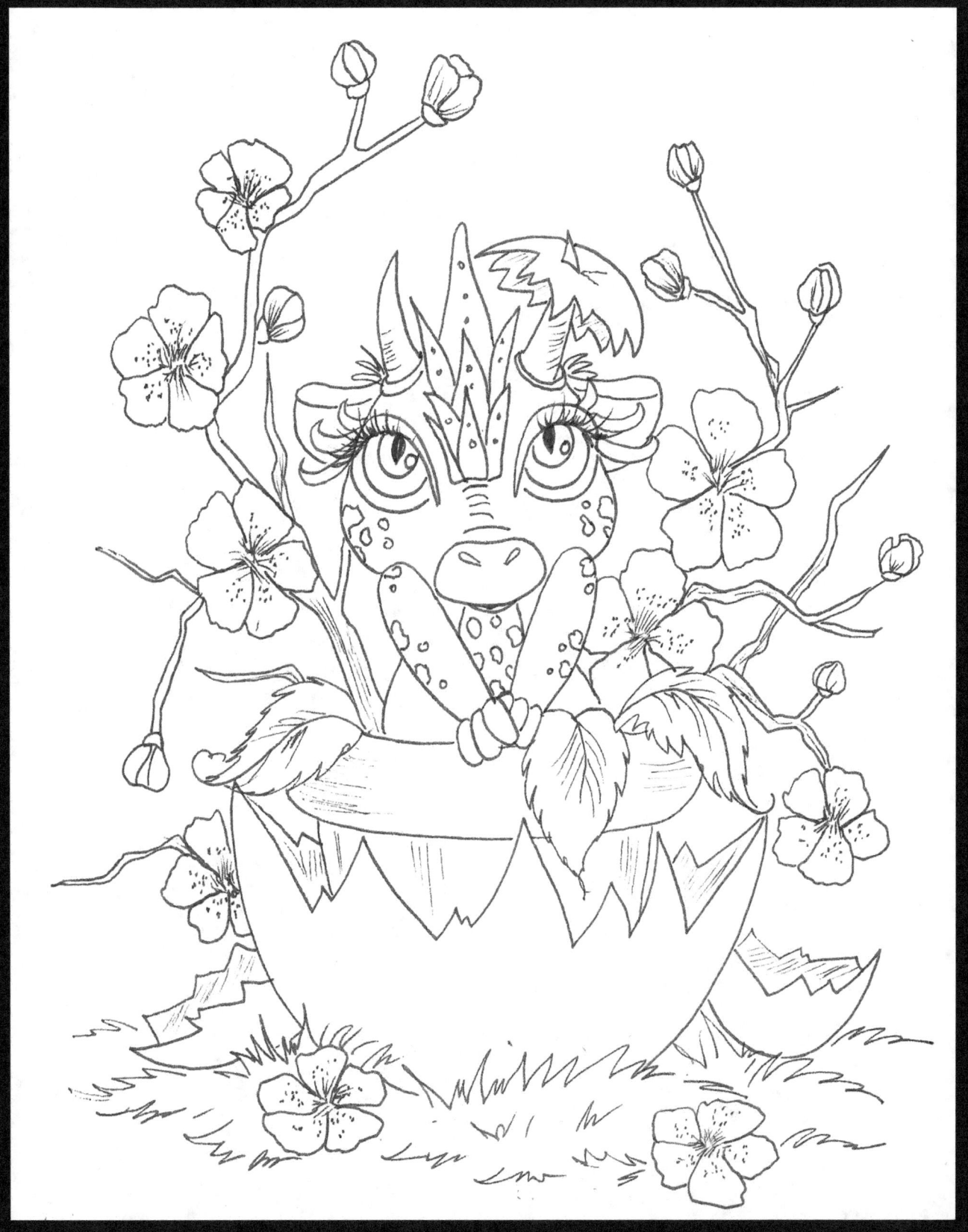

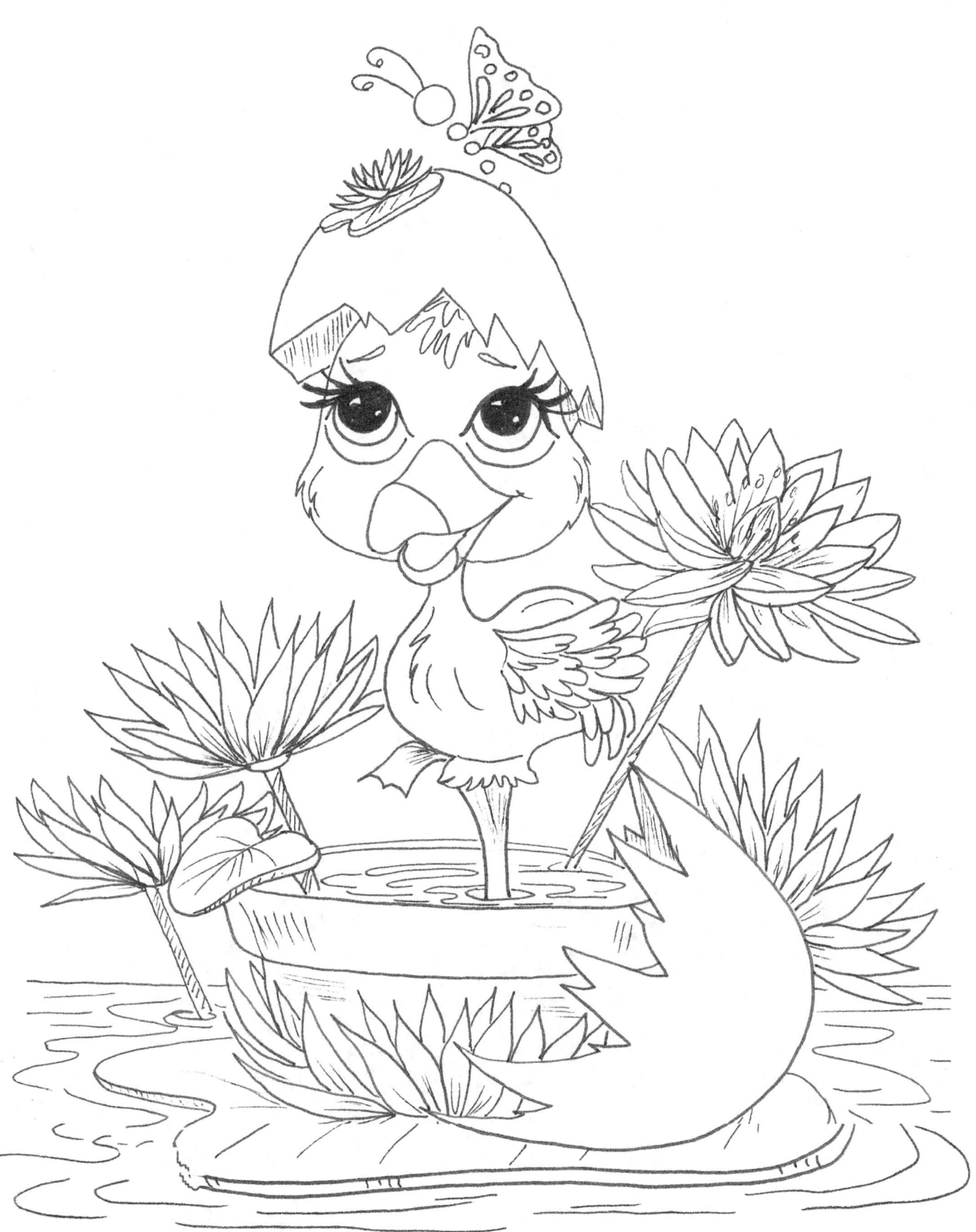

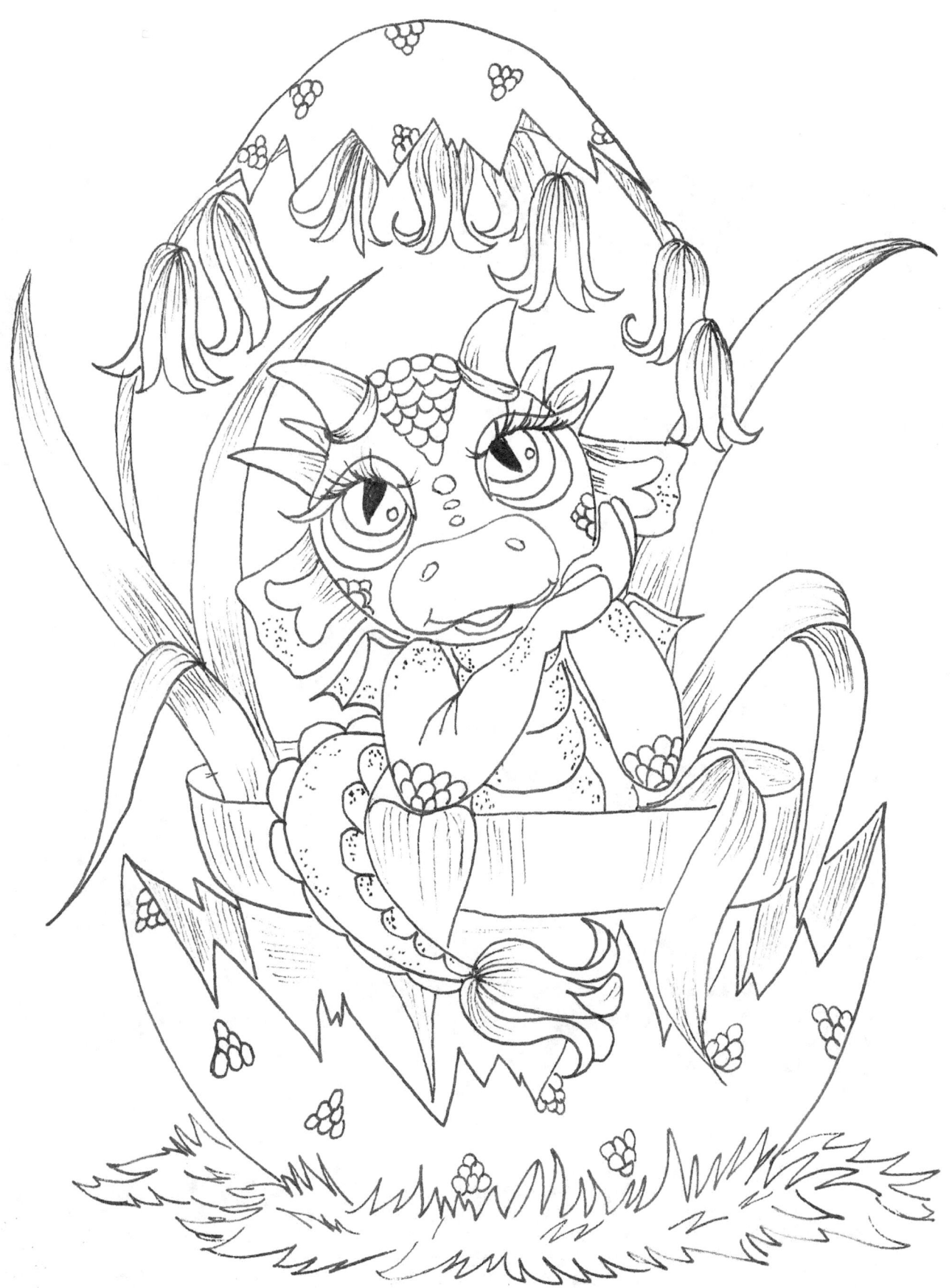

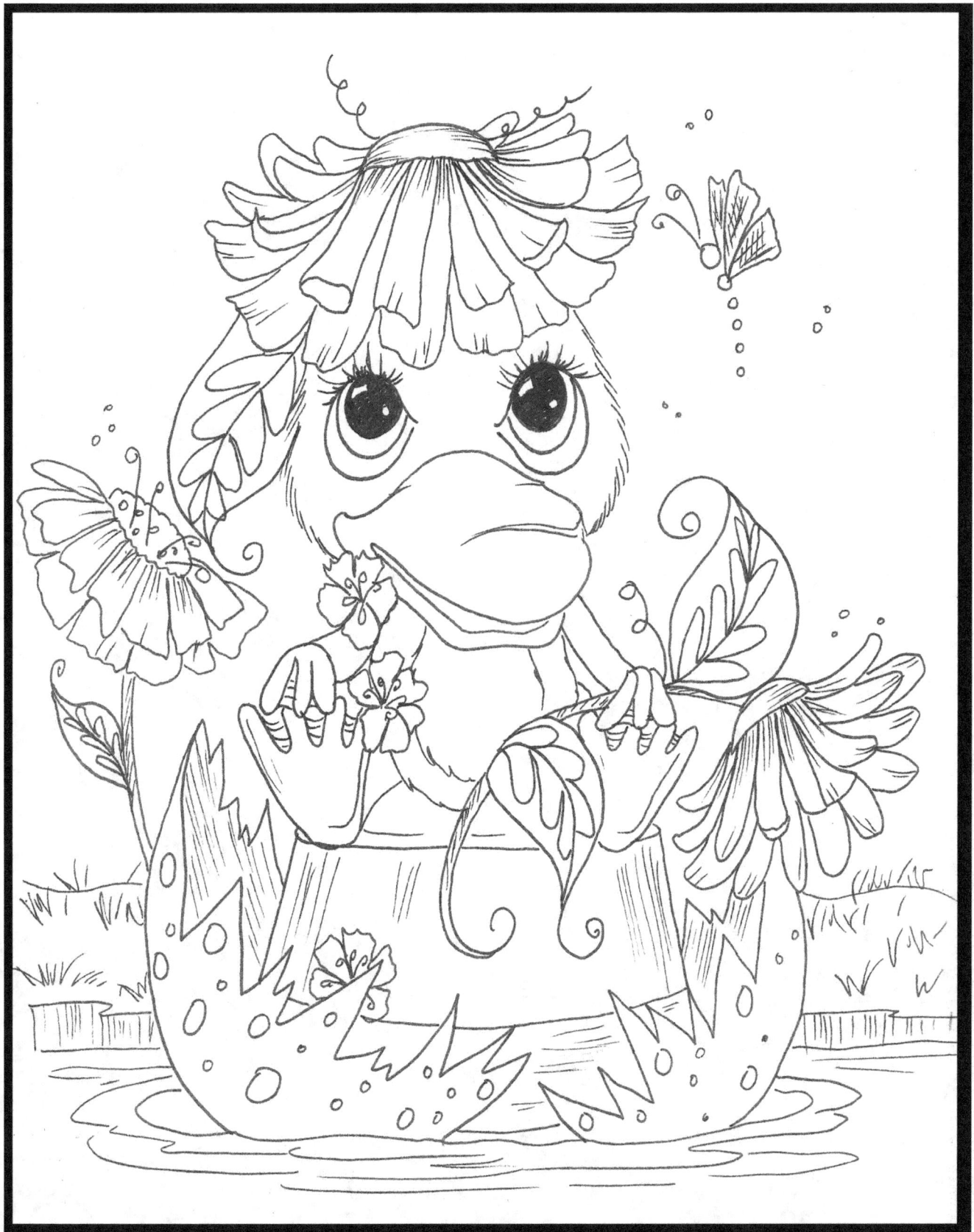

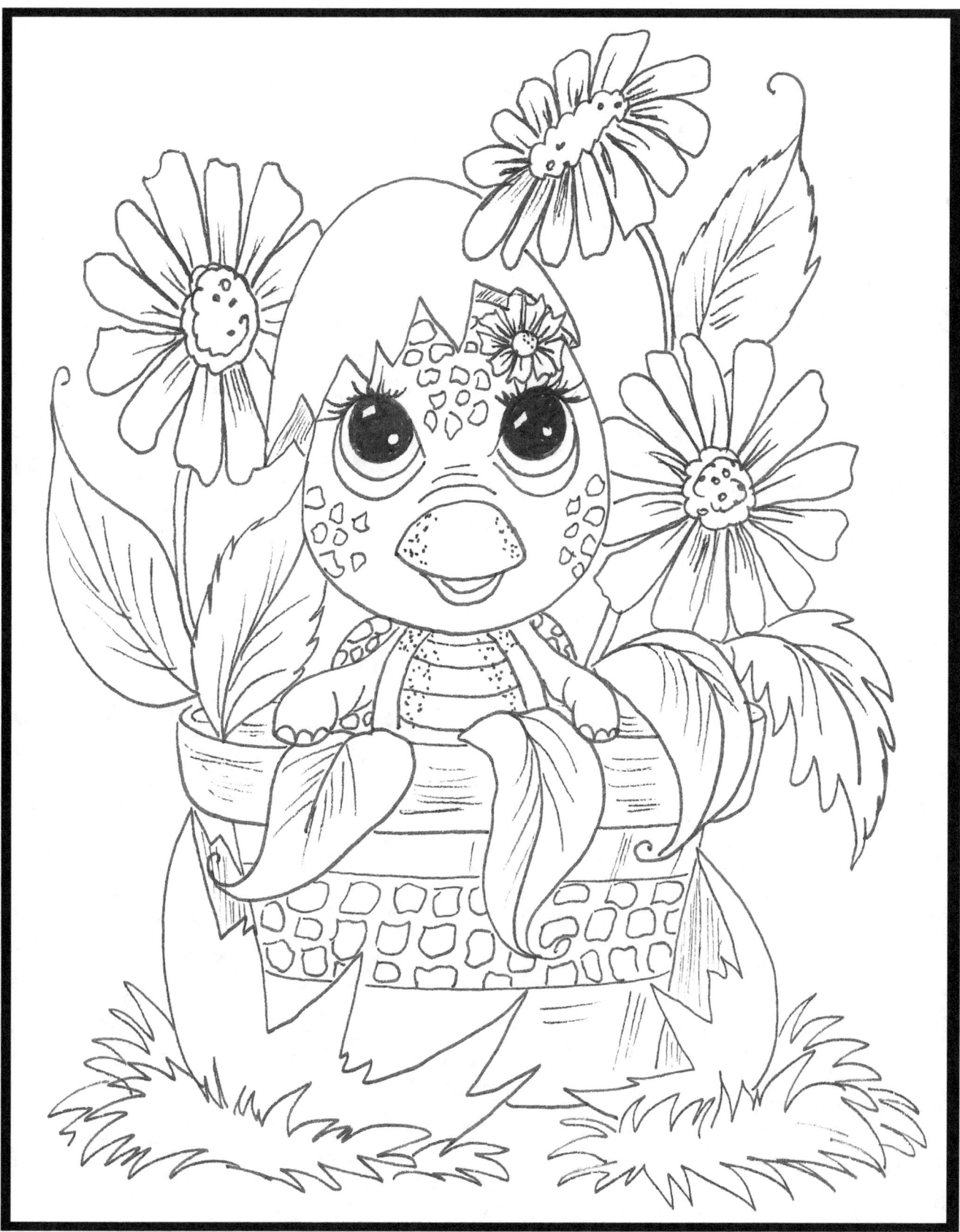

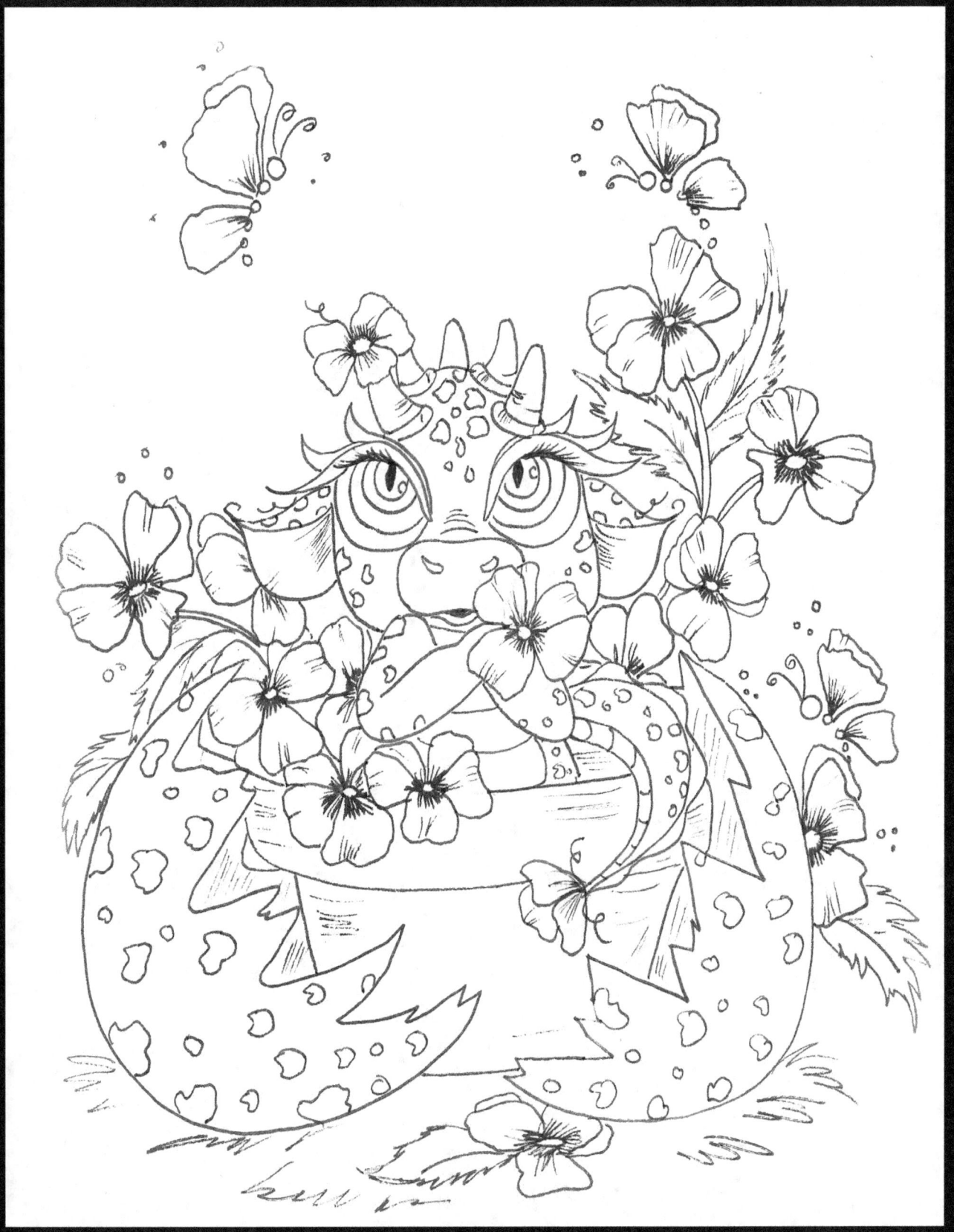

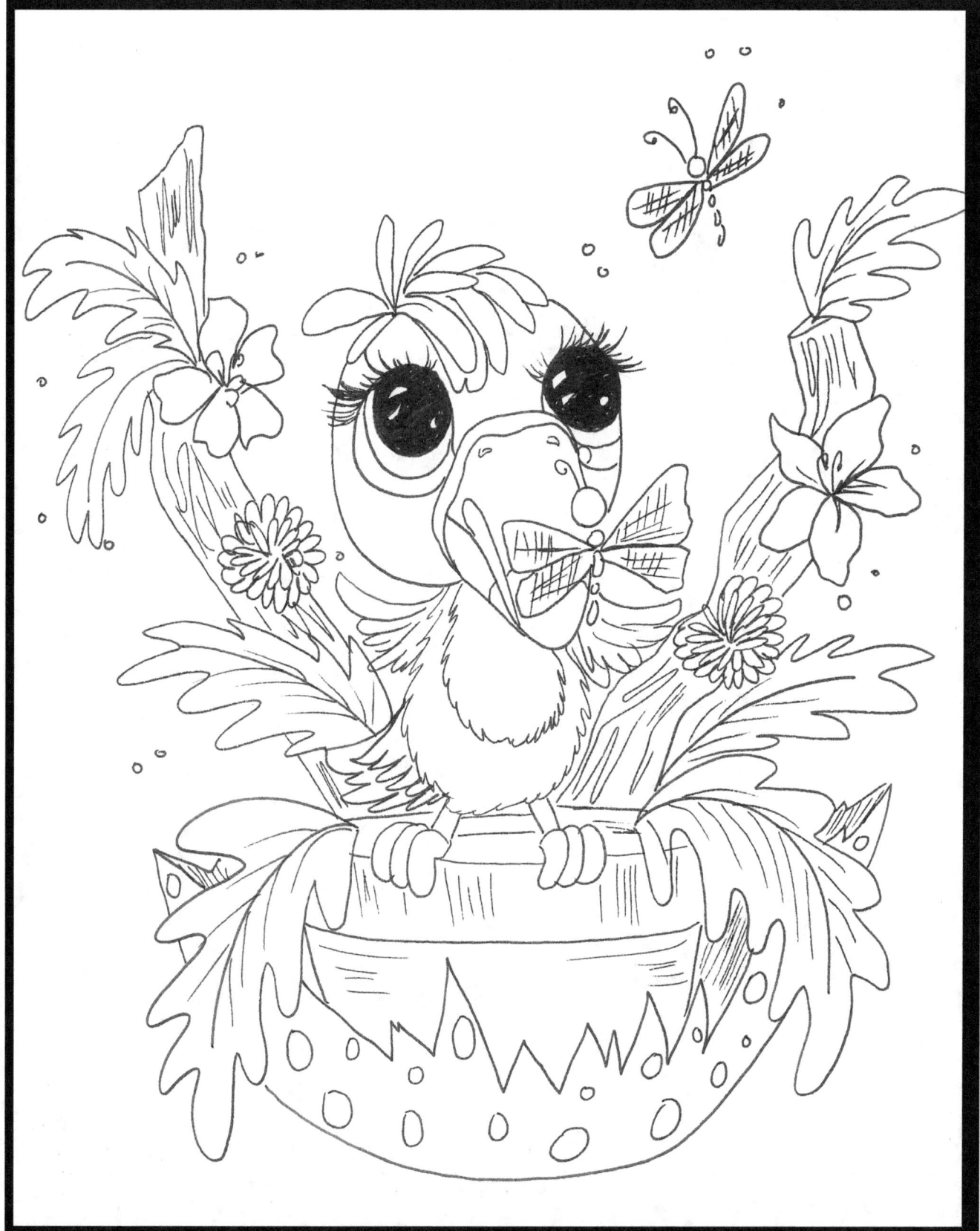

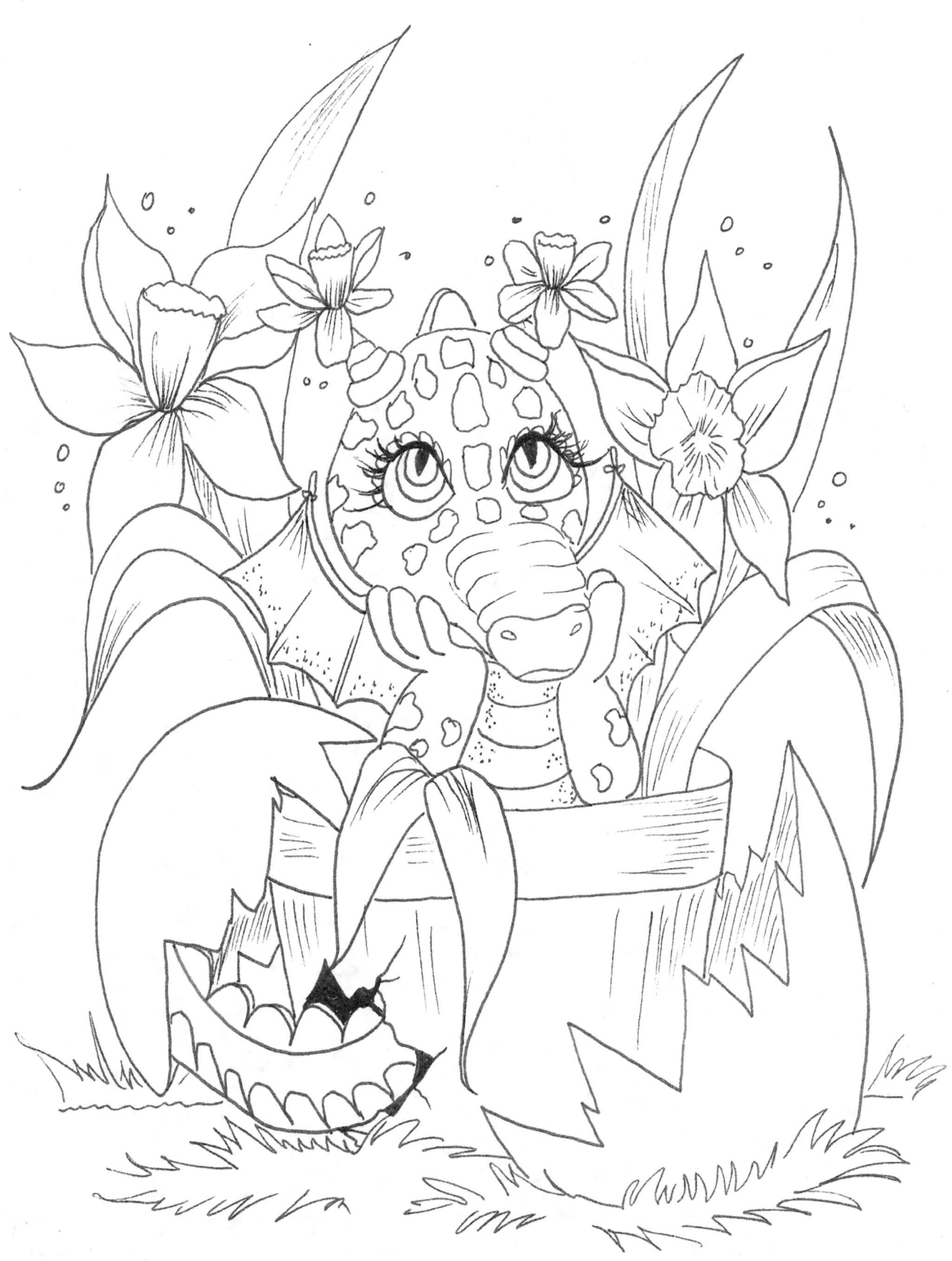

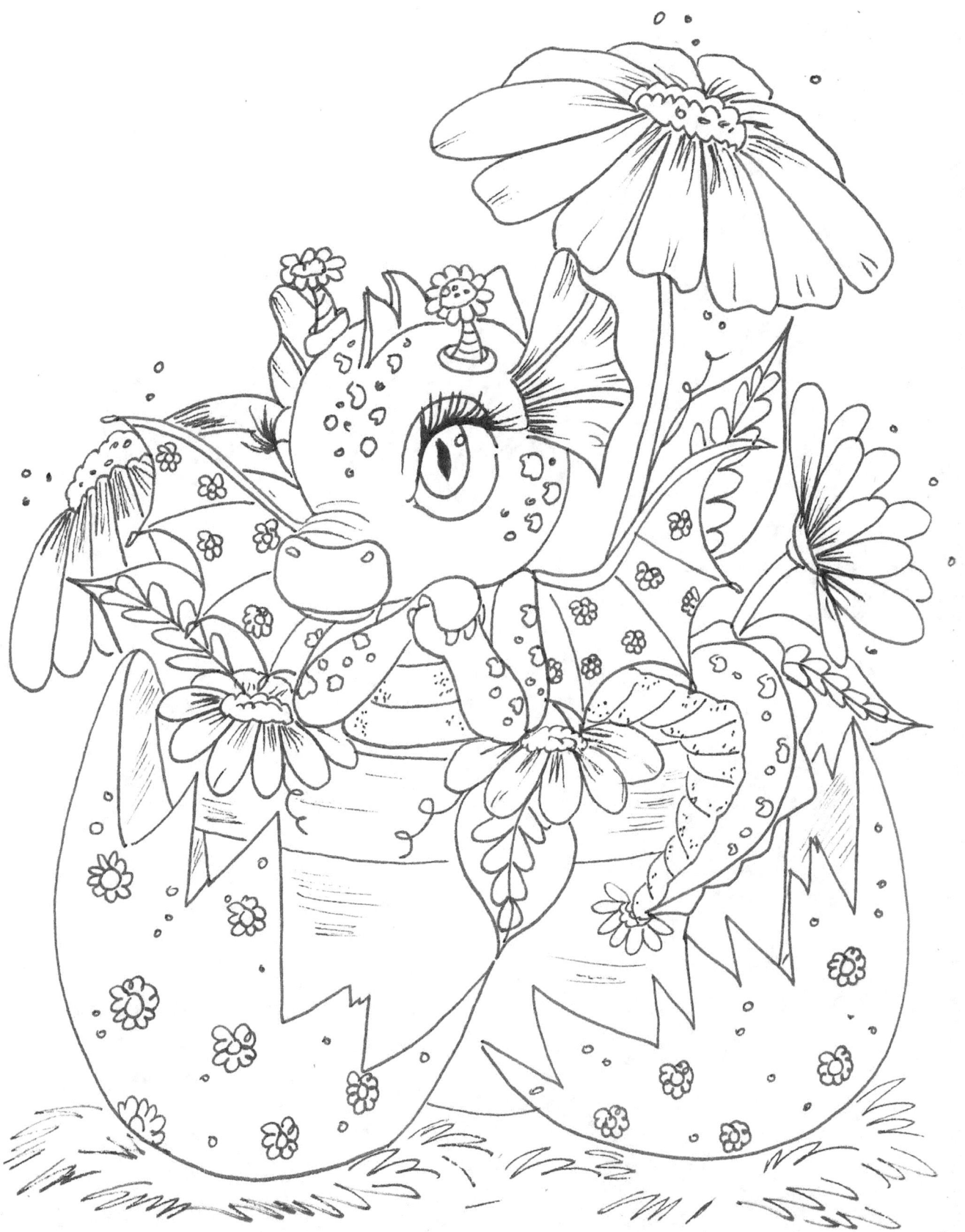

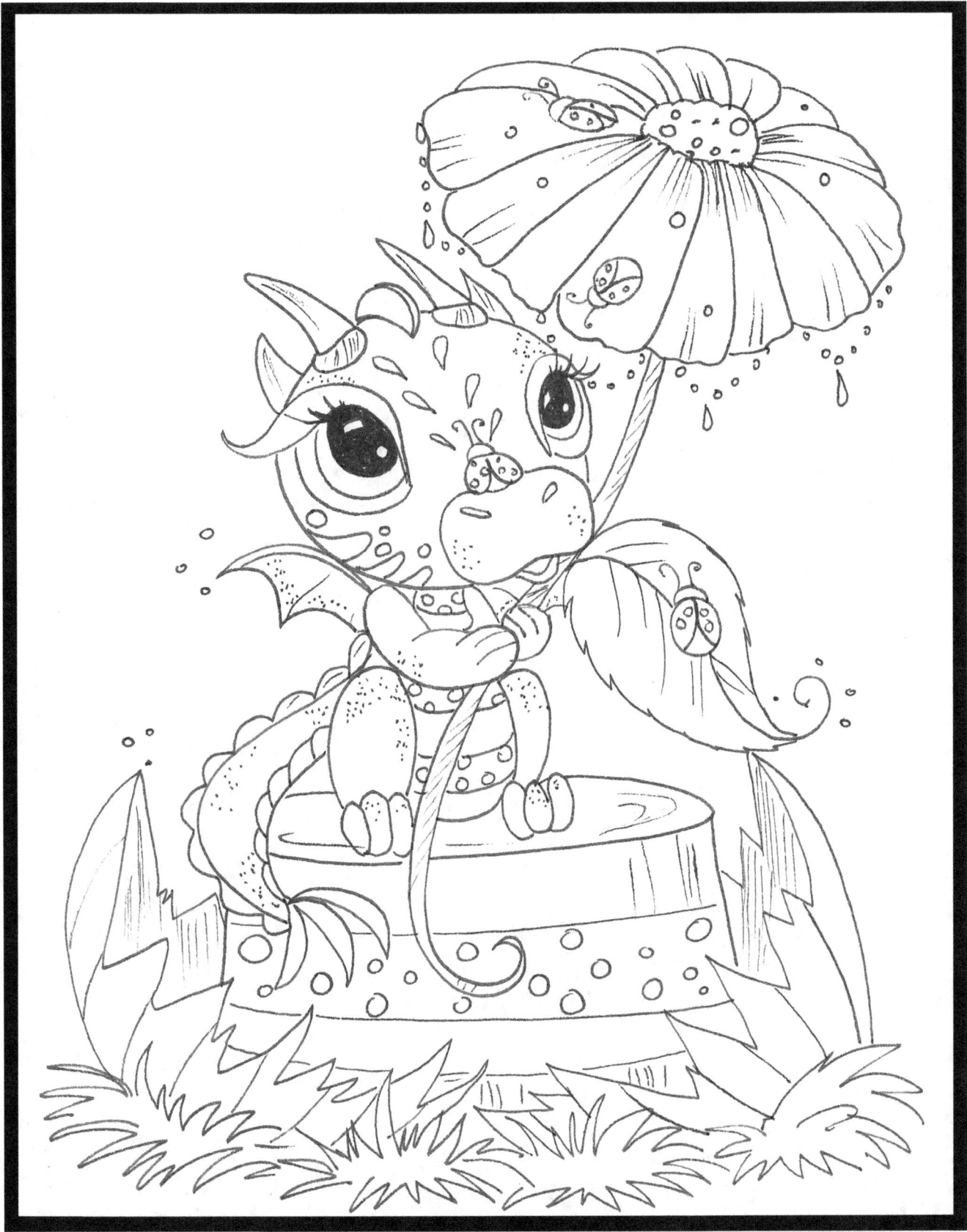

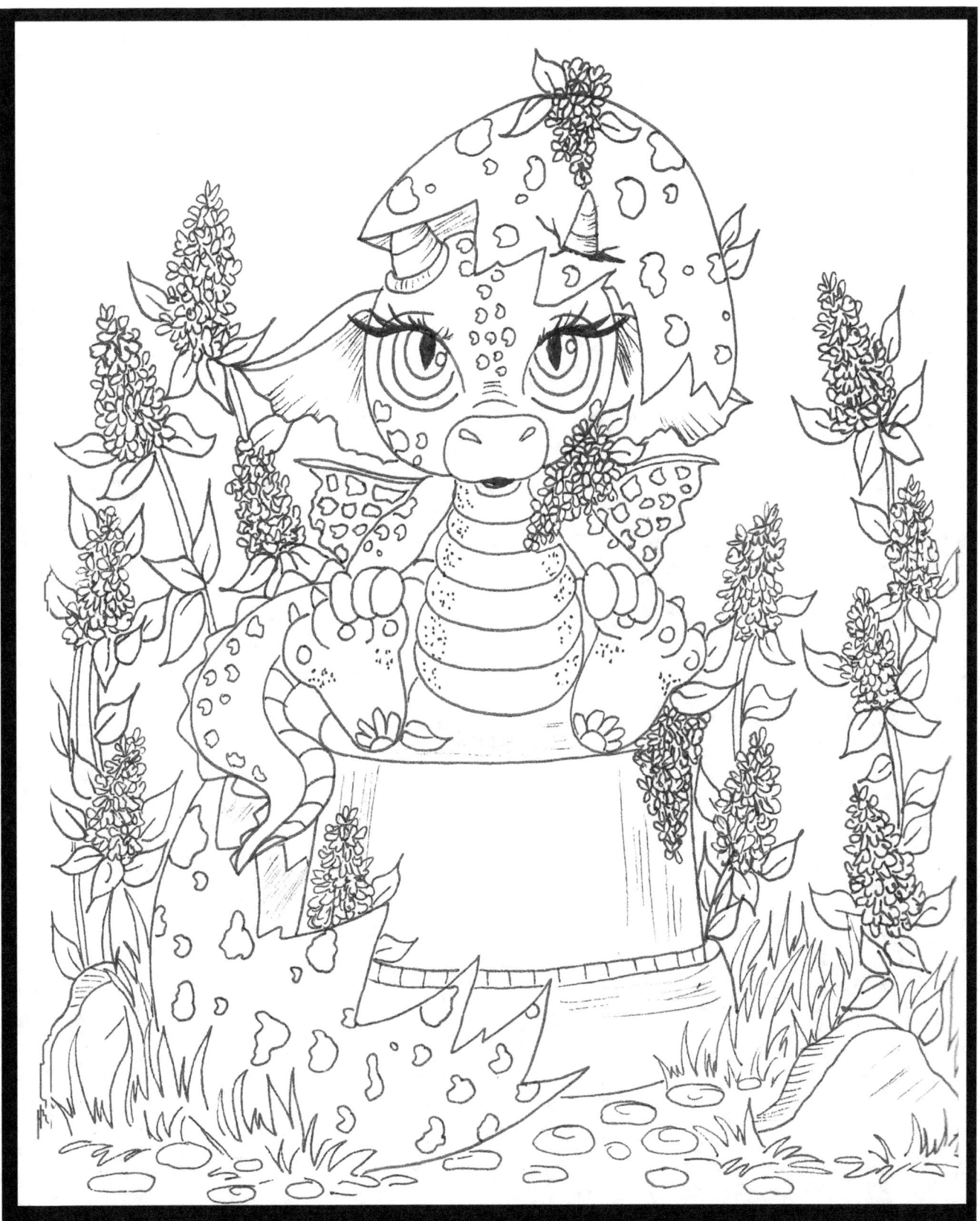

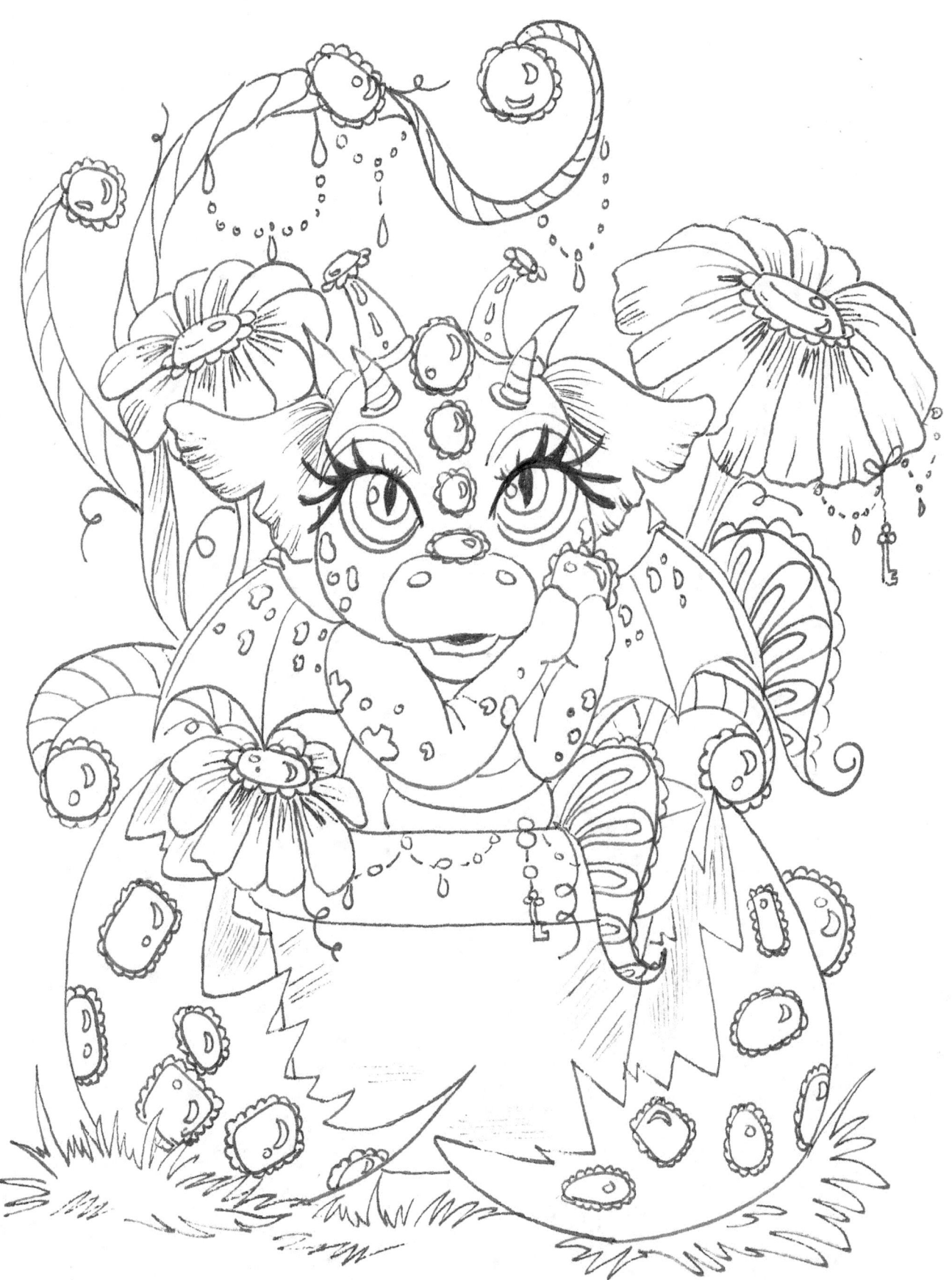

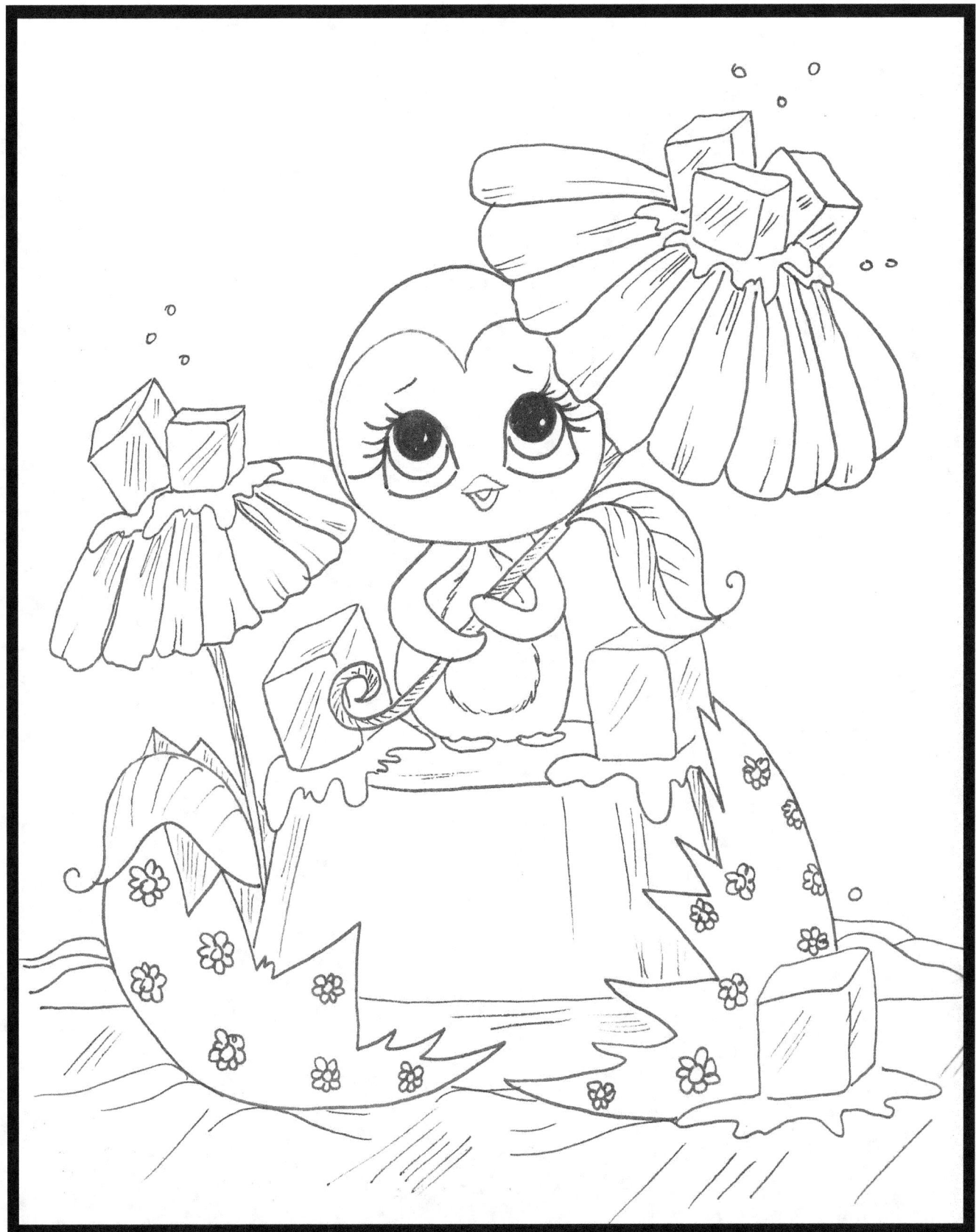

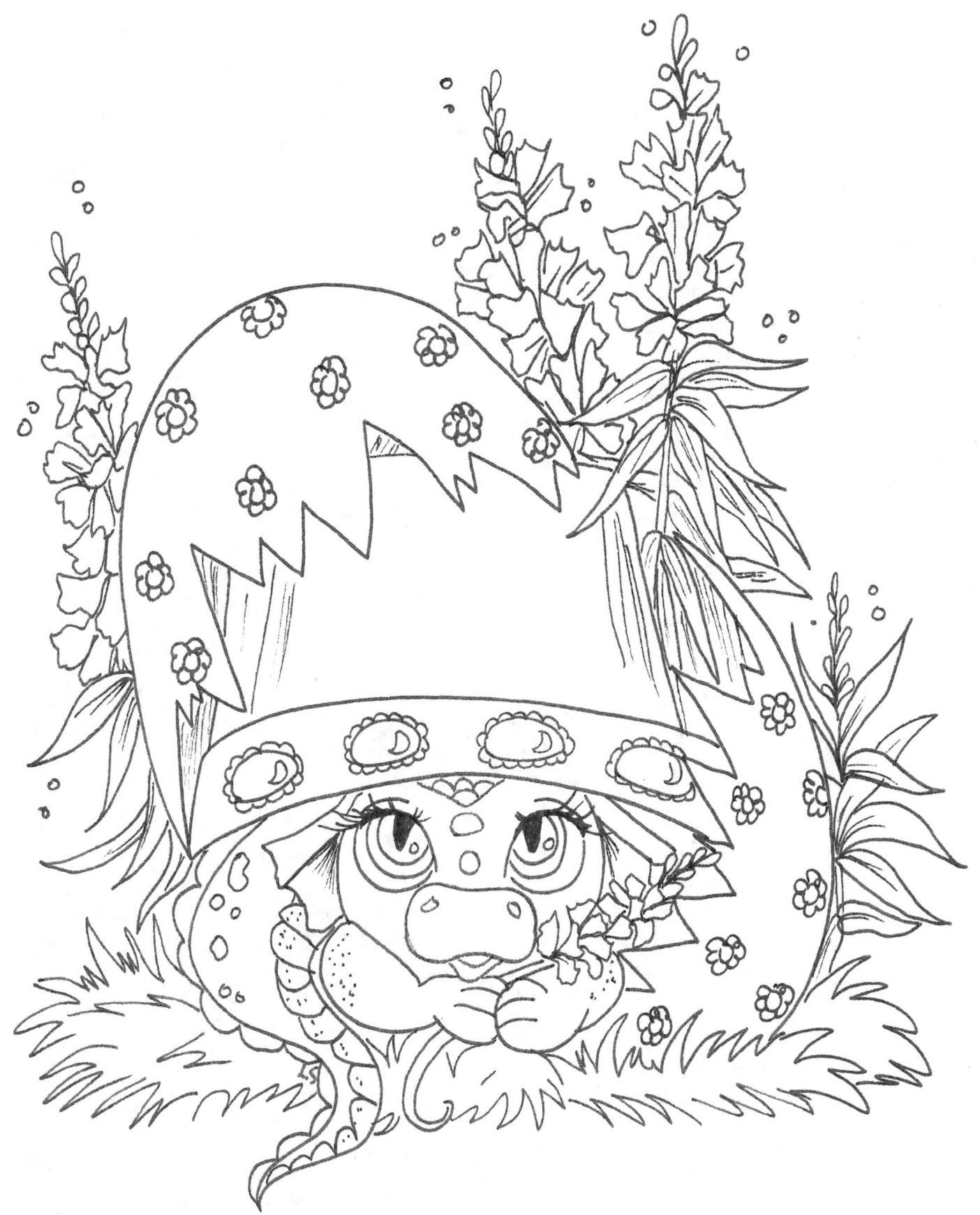

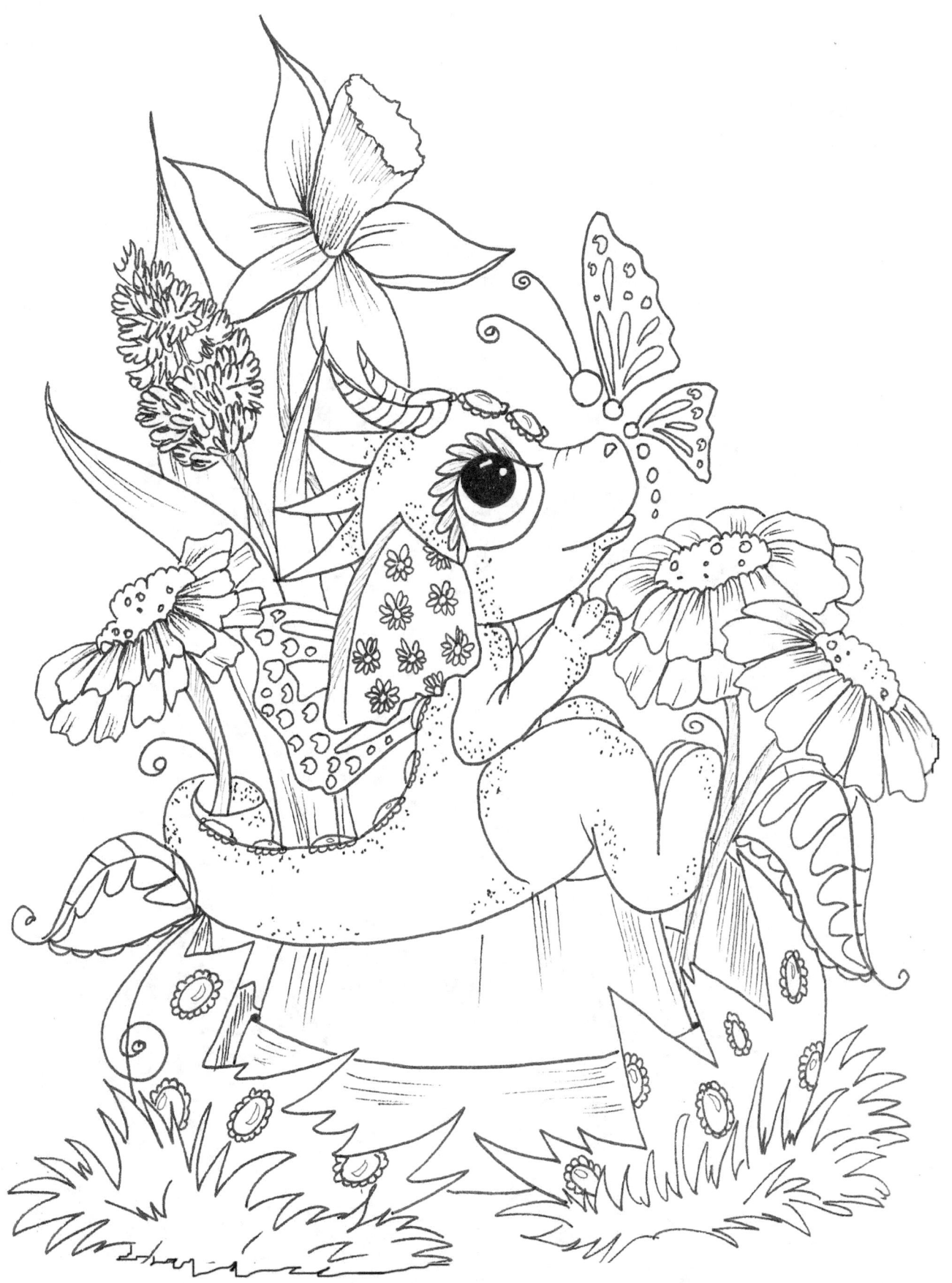

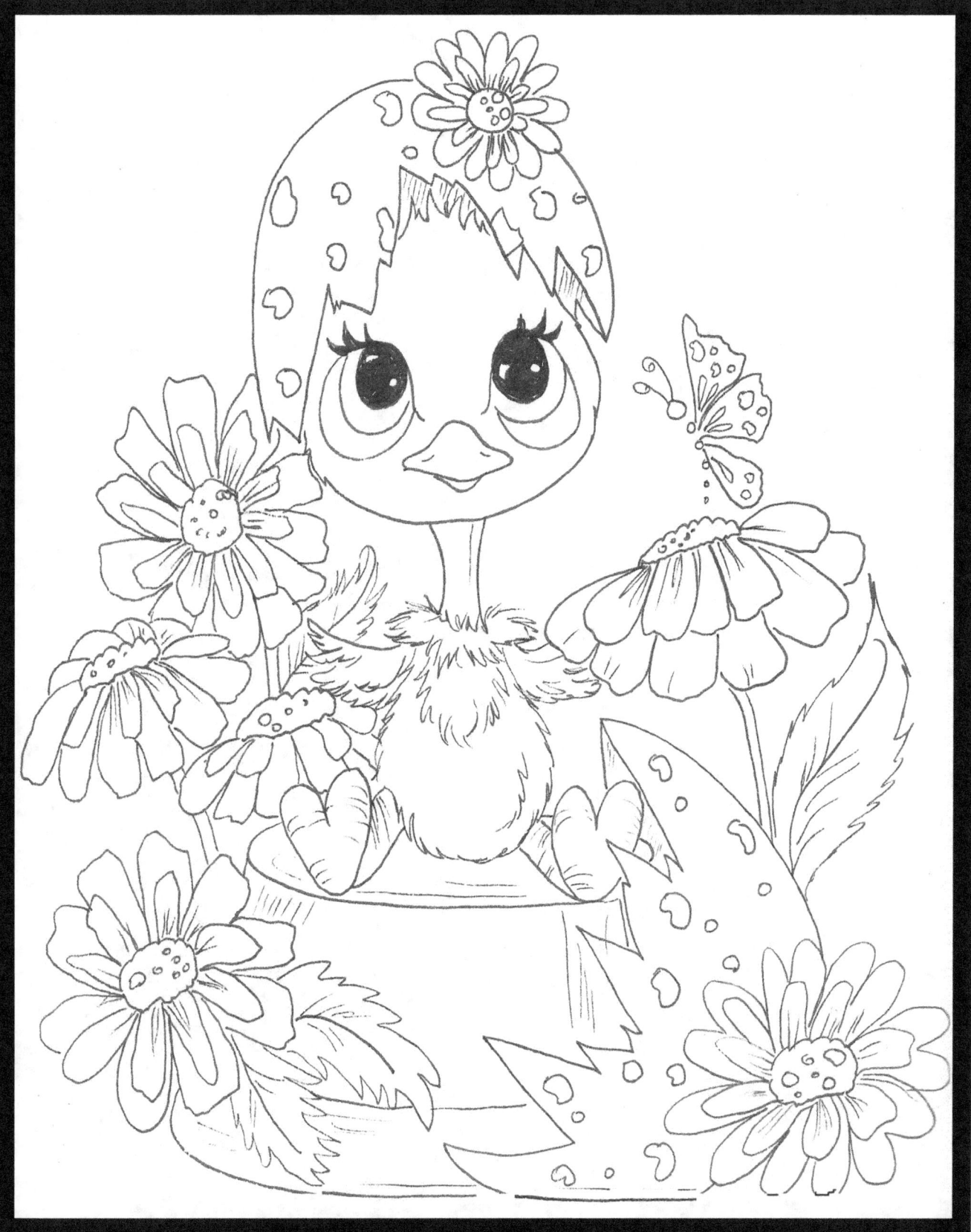

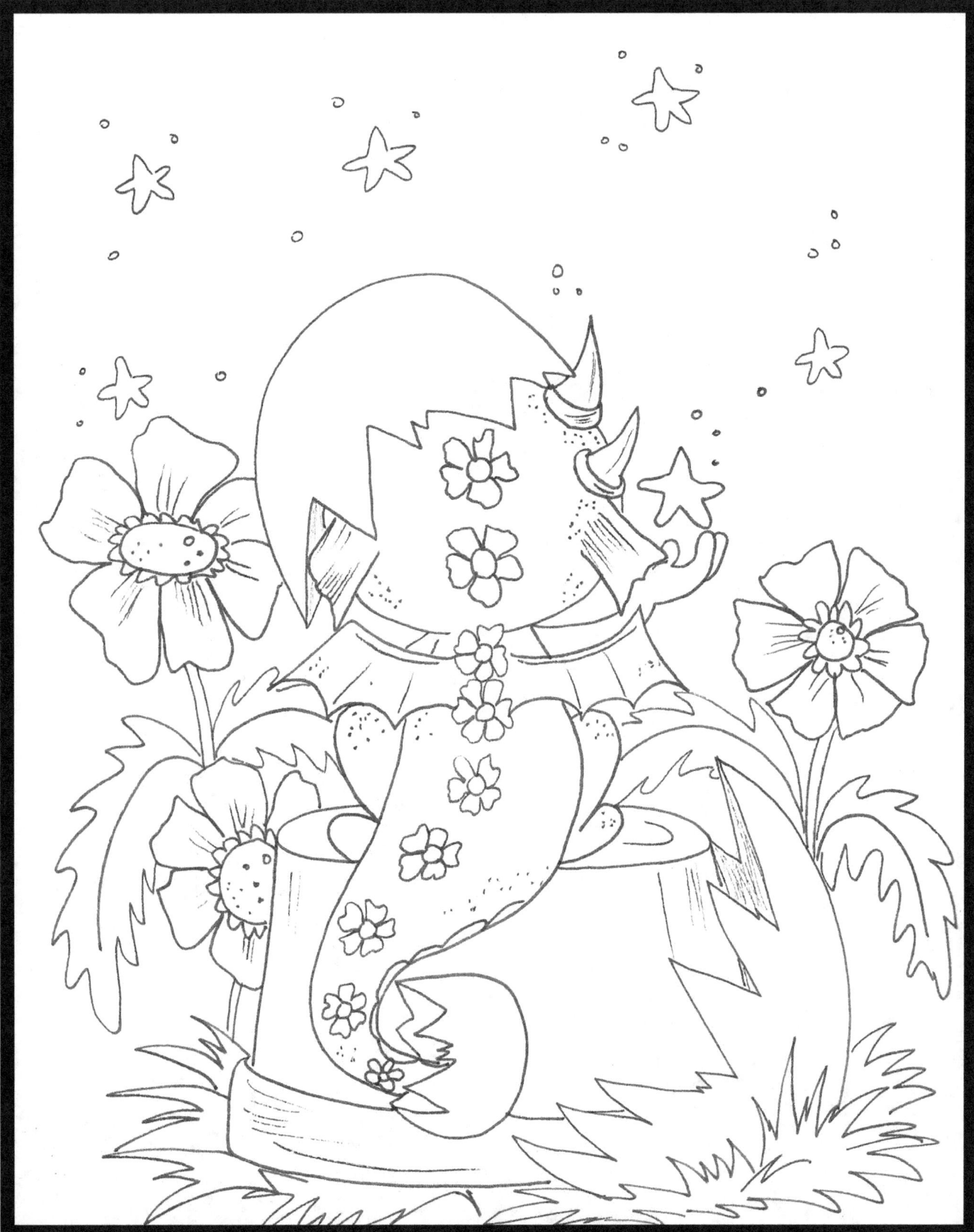

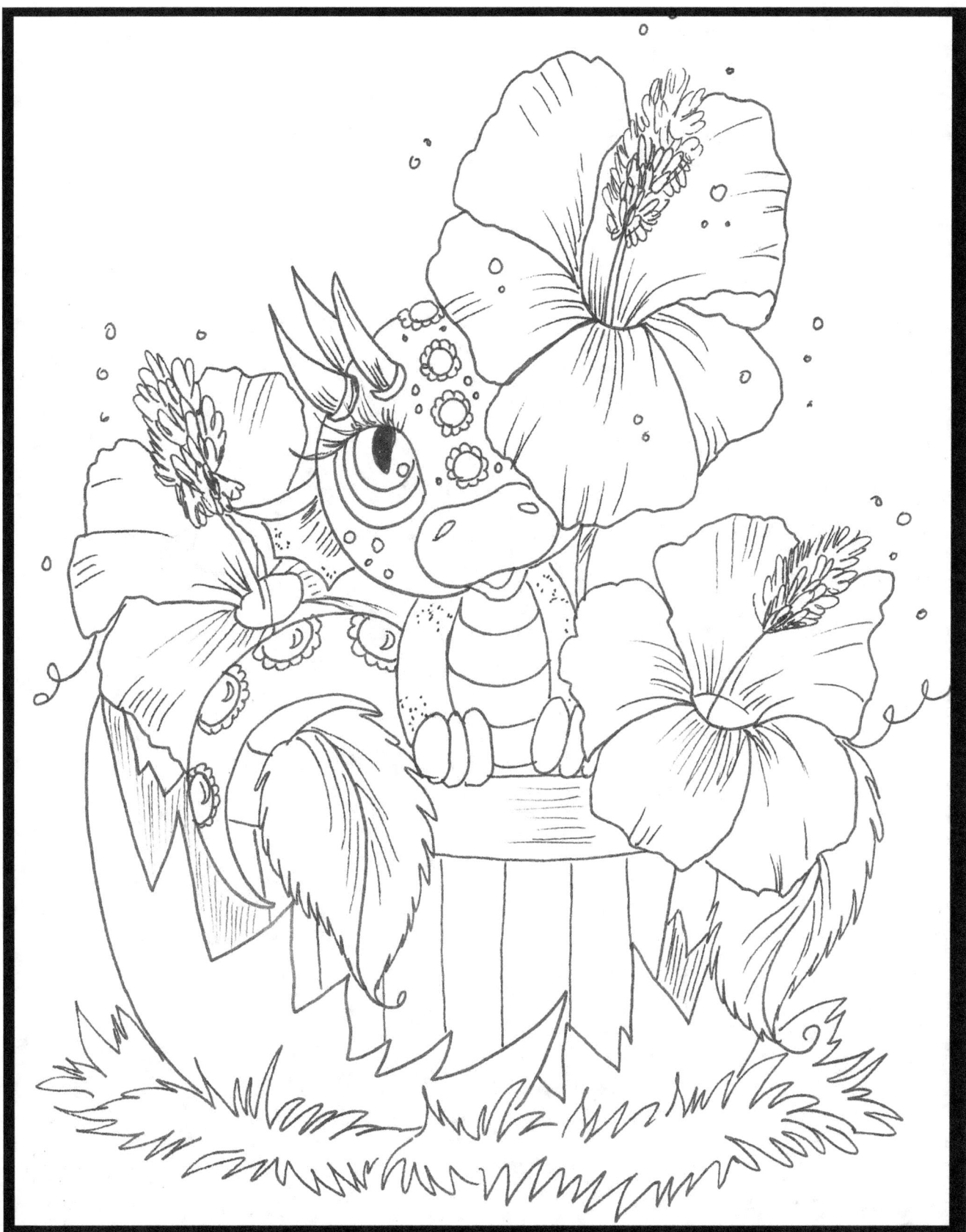